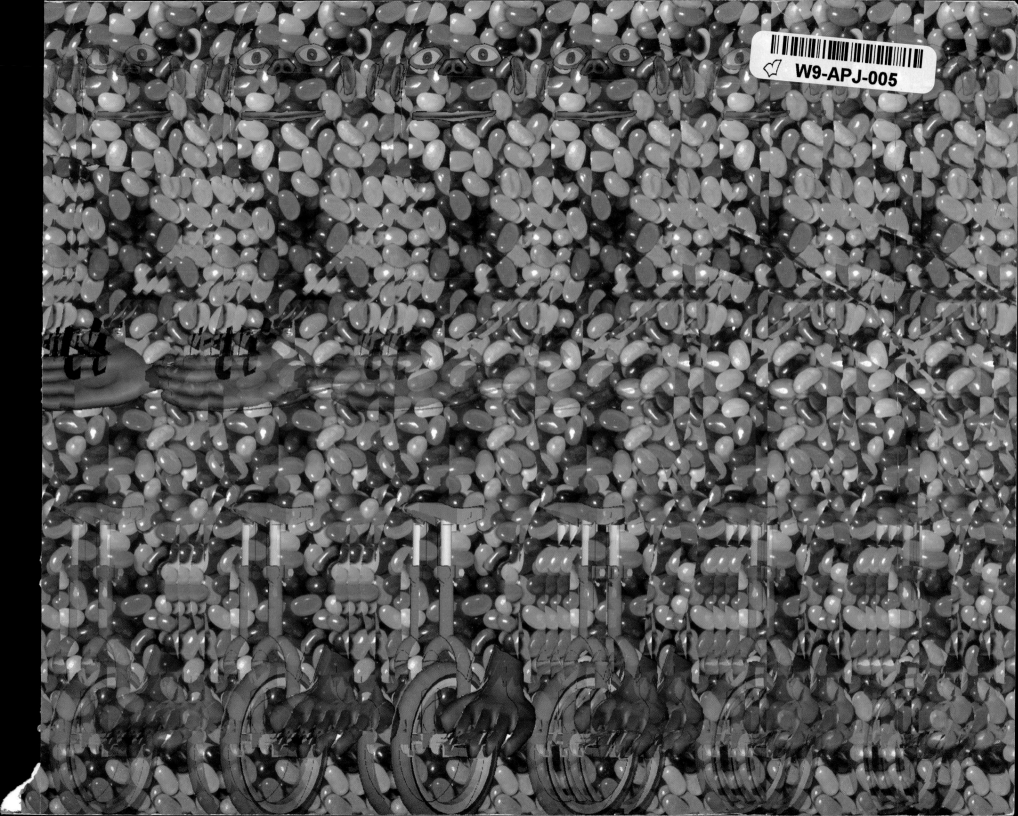

POWER VISION 2

HIGH DEFINITION 3D IMAGES BY BELLA VISTA PUBLICATIONS

DAY DREAM *D* PUBLISHING, INC.
Indianapolis, IN 46278

Artists: Ryan Jones, Otherworld Artyfax, Simi Valley, CA
Brian Small, Small Wonders, Orlando, FL

ISBN: 1-57081-832-0
First Printing: February 1995

This book is dedicated to Ryan, Marie, Brian and "Z", and all those who journey beyond appearances,

taking the cue that there's more to you, than our limited view, and experiences.

F O R W A R D

As we come into this world we embark on a journey of self discovery. We hear, feel, smell, taste and see our world little by little, forming the "picture" that we later call "our" reality. Yet we are all different, describing to ourselves and the world around us our own unique viewpoint. How is this possible? Is not a stone hard to anyone's touch; is not the coat of a bunny rabbit soft to all; is not injustice, injustice for all?

Somewhere between the natural experience of the senses, and that which is being experienced is a veil of meanings, a decoding screen or filter that all experience passes through. It is in the "zone" that life holds its greatest gift. This is the zone of interpretations, where we interface our senses and the world. It is also the greatest challenge to mankind. For in this zone is the possibility to share and confirm together our similarities. It is here that we can overcome our differences and unlock the door to the field of unity from which we have all sprung.

The popularity of 3D images is a proof of this unity. For hidden behind each 3D pattern is a particular image. Once we see it, we want to share it with others. How many times have you said, "can you see it"? Can you "see" it? Once shared we all are happy. We want others to "see" what we see. This is the unifying factor in us all. To share and enjoy the real meaning of life together, confirming the unity of our humanity, and the one source from which we have all come, and to which we are all returning.

— David Sterling

I N T R O D U C T I O N

Power Vision is overjoyed to welcome you to another adventure into the dazzling world of 3D images. It seems that we can't get enough of this most entertaining art media. I can just hear those voices out there saying, "can you see it?" Can you see it?

This new offering of Power Vision images, will thrill and excite you. They have been created by some of the best 3D Artists in the industry for your enjoyment.

For those with Power Vision experience, these will be a welcome addition to your collection of visionary delights. For those of you new to Power Vision, get ready for an exciting adventure. You will discover the Power Vision of your inner sight.

EXPERIENCE THE POWER!

HOW TO GET THE POWER!

There are four basic ways to achieve Power Vision.

Power Vision, technique: Alpha.

Hold the image approximately eight to twelve inches from your face. Relax your eyes. Do not try too hard - the Power Vision has to flow from you. It is helpful to find a shiny part of the image, a place from where a light source is reflecting. Look into the light source, and let go. As your Power grows, the image emerges. Once it "pops" in, let the Power take over.

Power Vision, technique: Beta.

Hold the image right up to your face, your eyes should be relaxed, so that all you see is a blur of colors. Hold your gaze as you slowly move the image away from your face. Do not let your gaze vary from its focus. As the distance increases, you will "feel" the Power. Hold your glance, let the picture float, and the image will appear.

Power Vision, technique: Gamma.

Focus on something a short distance away. Hold your focus in the distance and bring the Power Vision Book image into your peripheral vision. The 3-D image should appear.

Power Vision, technique: Omega.

This is the most Powerful technique of all! Caution, it may be all too Powerful at once, so hold on to your head! Look into the Power Vision image and with your will, move your eyes into a slightly crossed position. Holding the eyes in your power, let the image emerge!

Now that you've got the Power, share it with others!

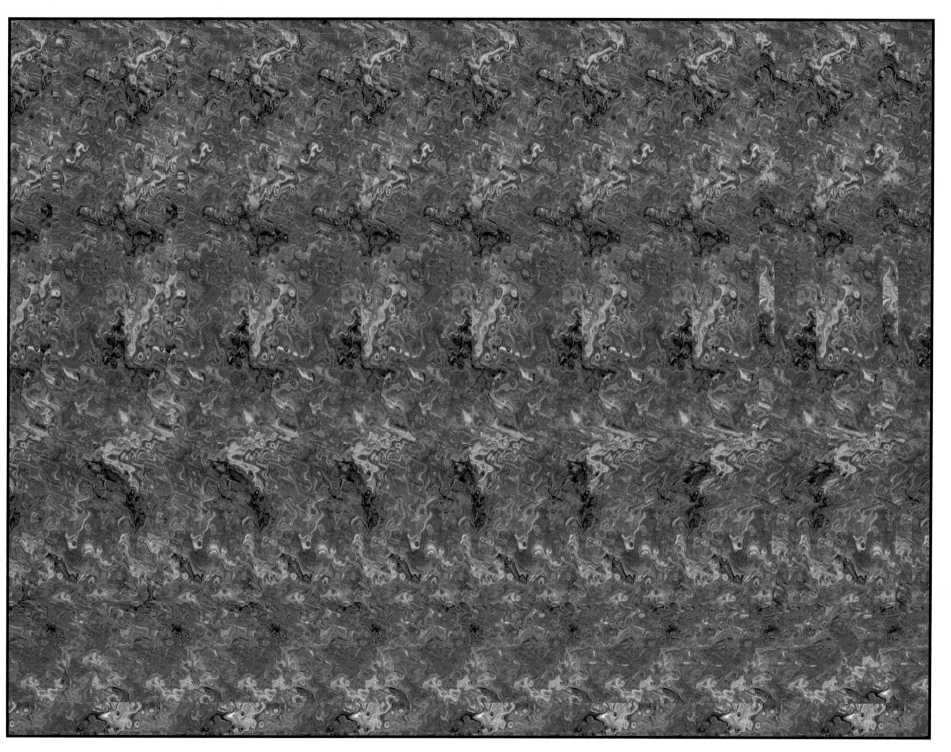

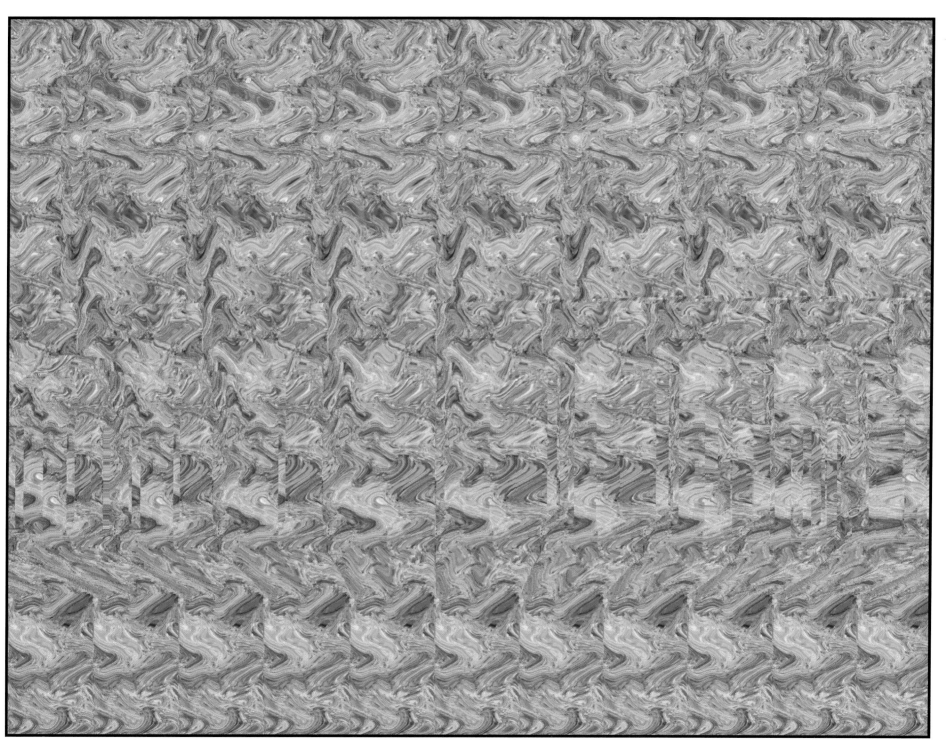

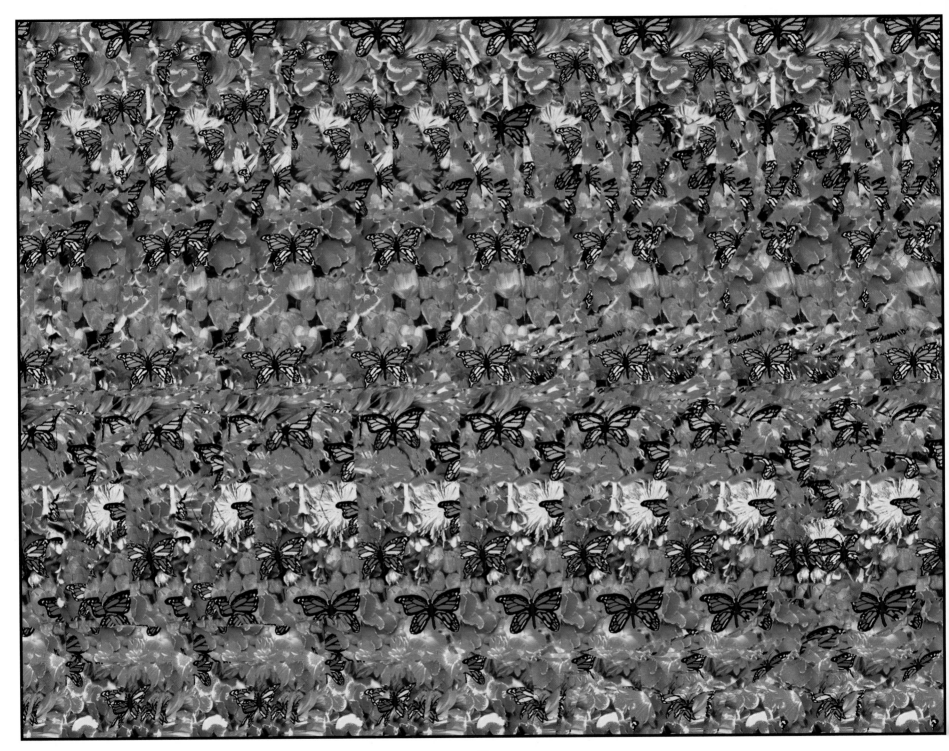

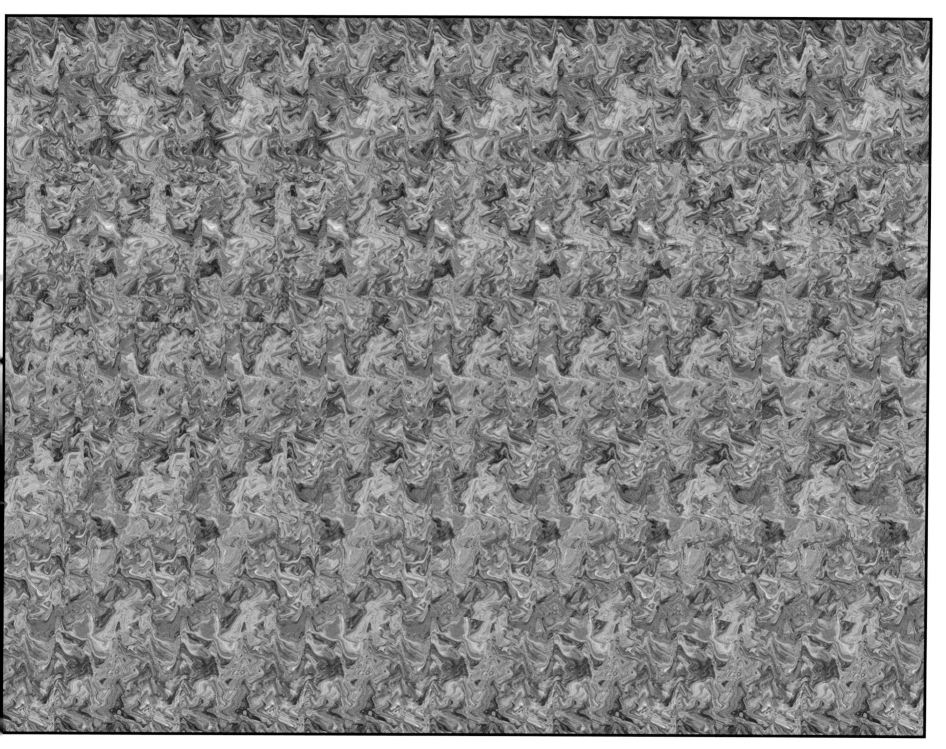

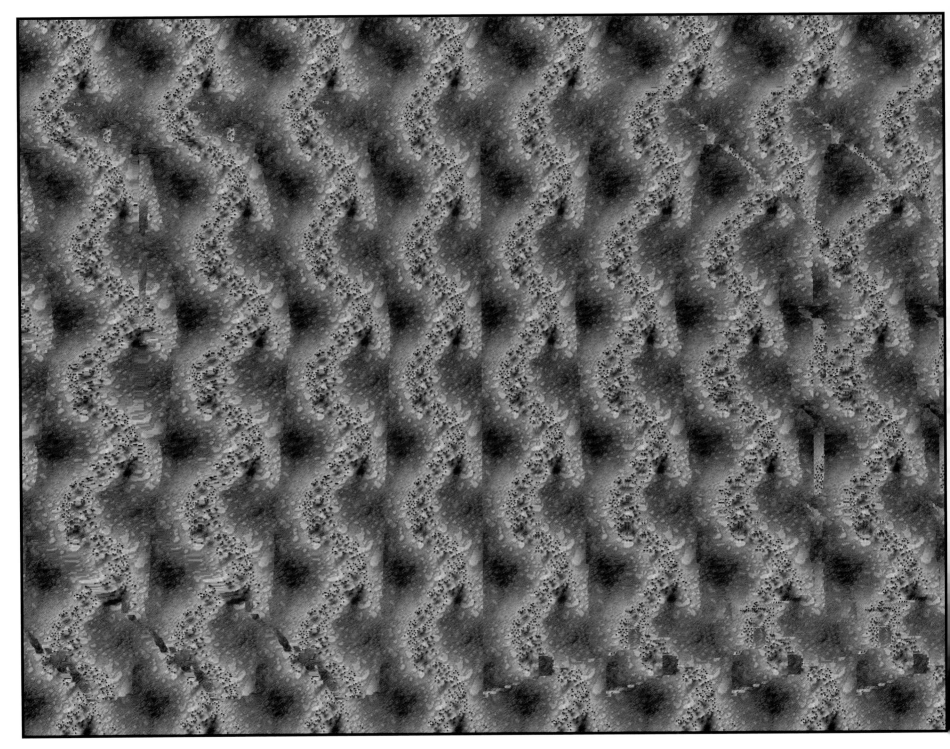

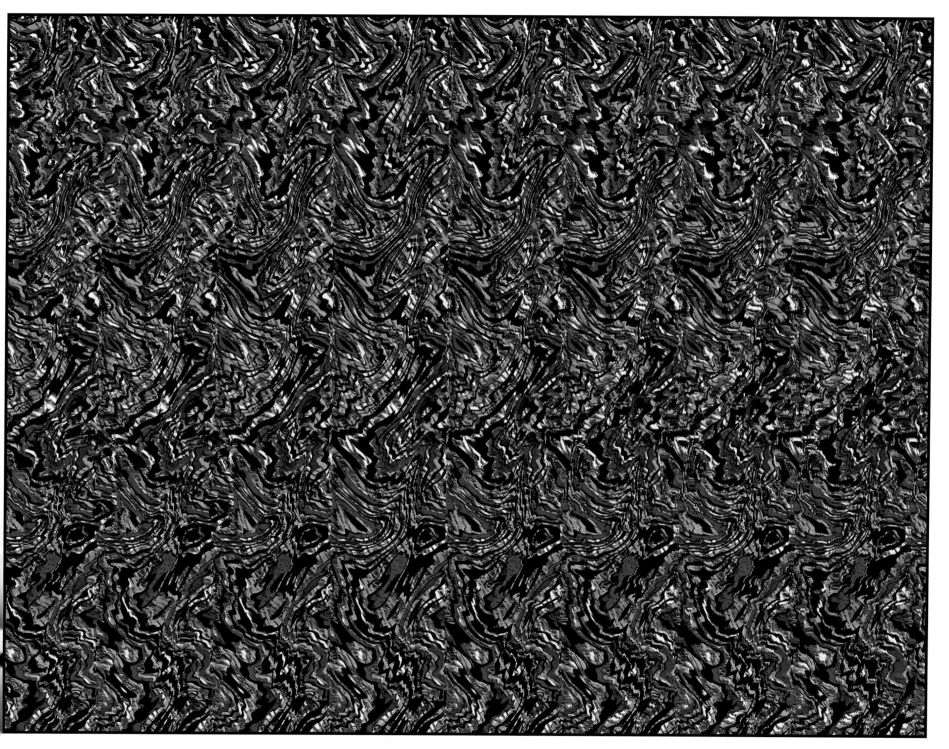

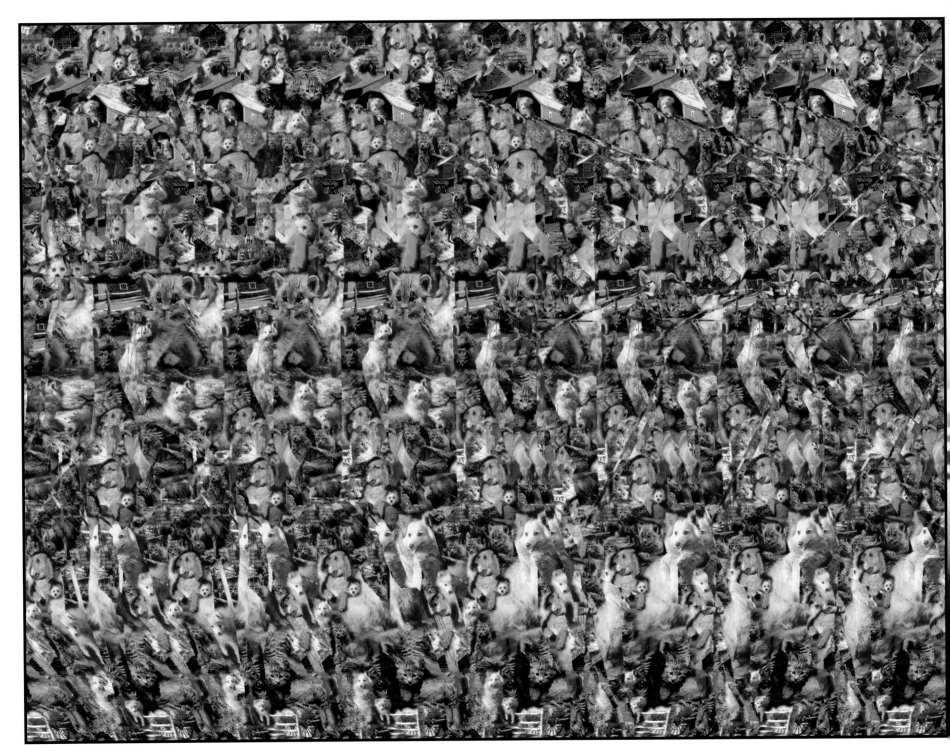

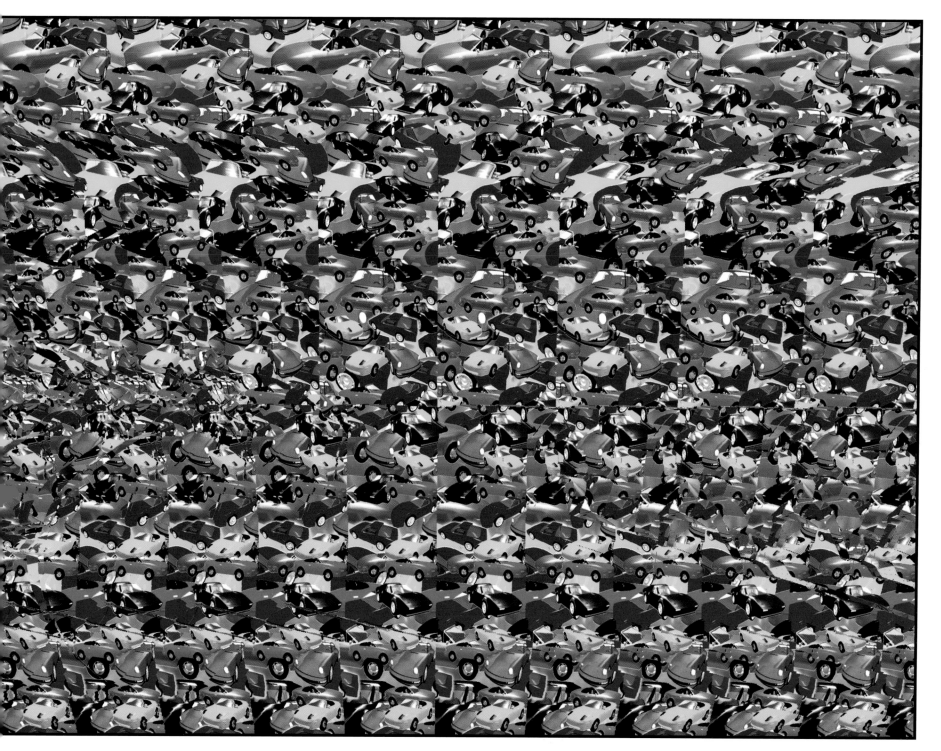

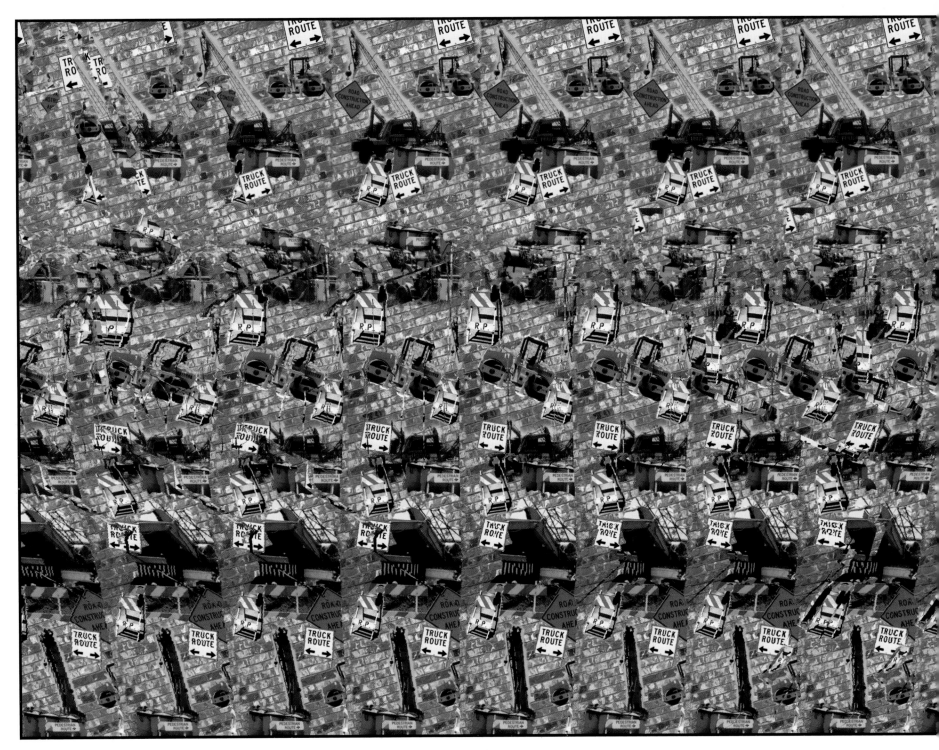

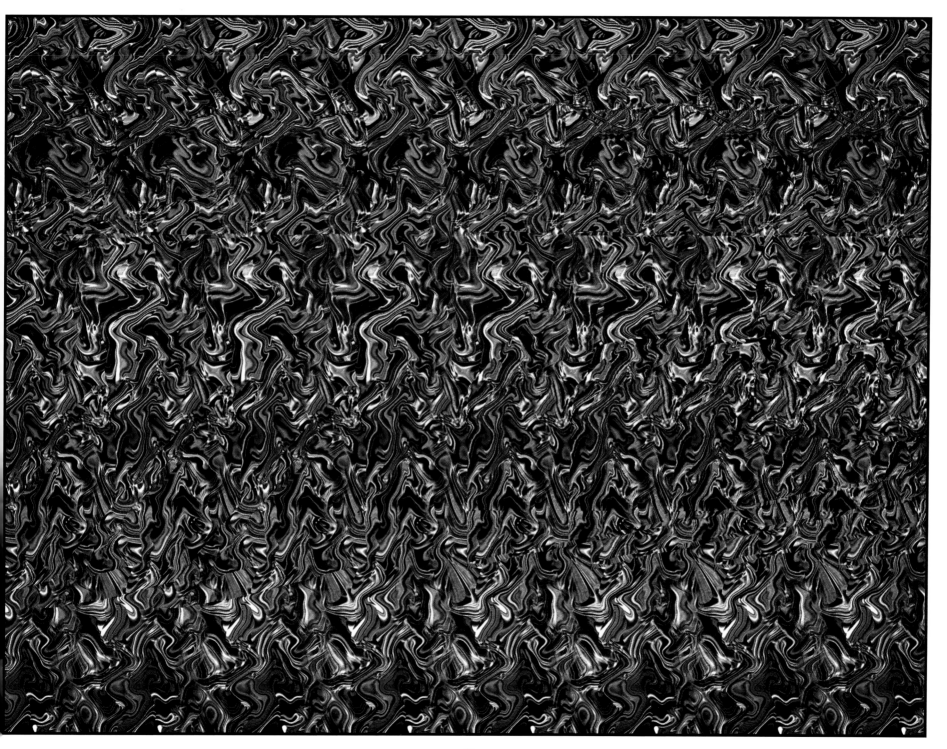

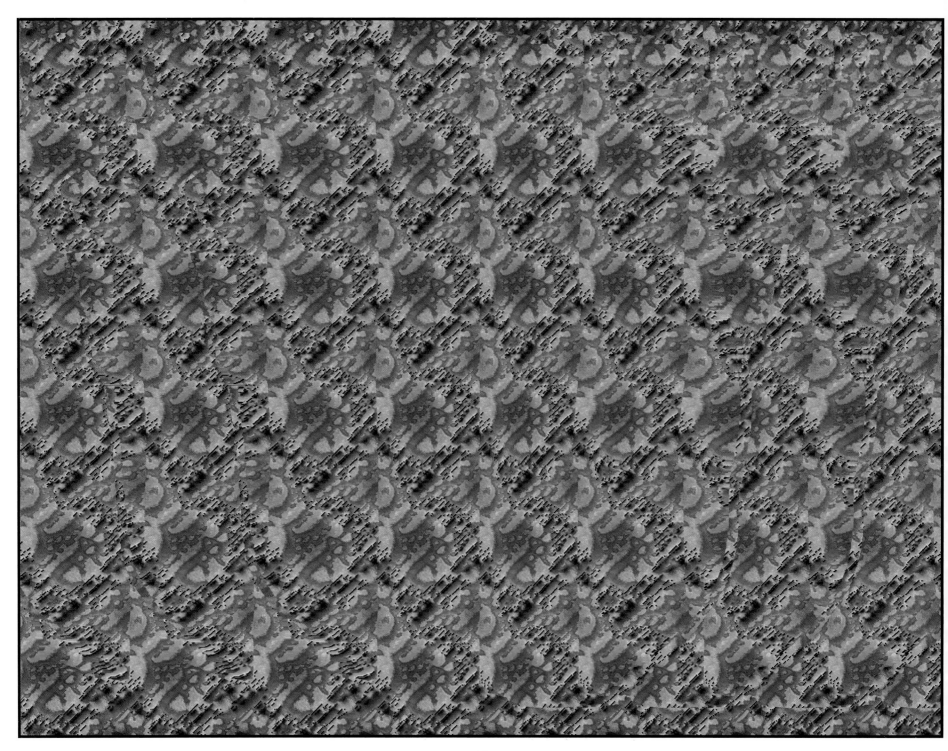

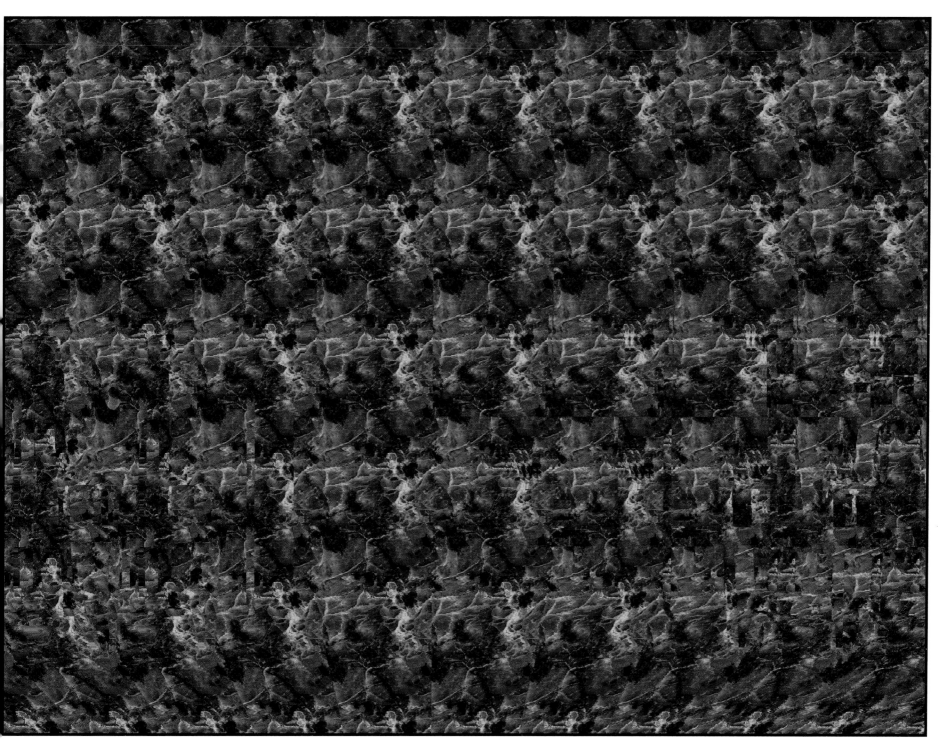

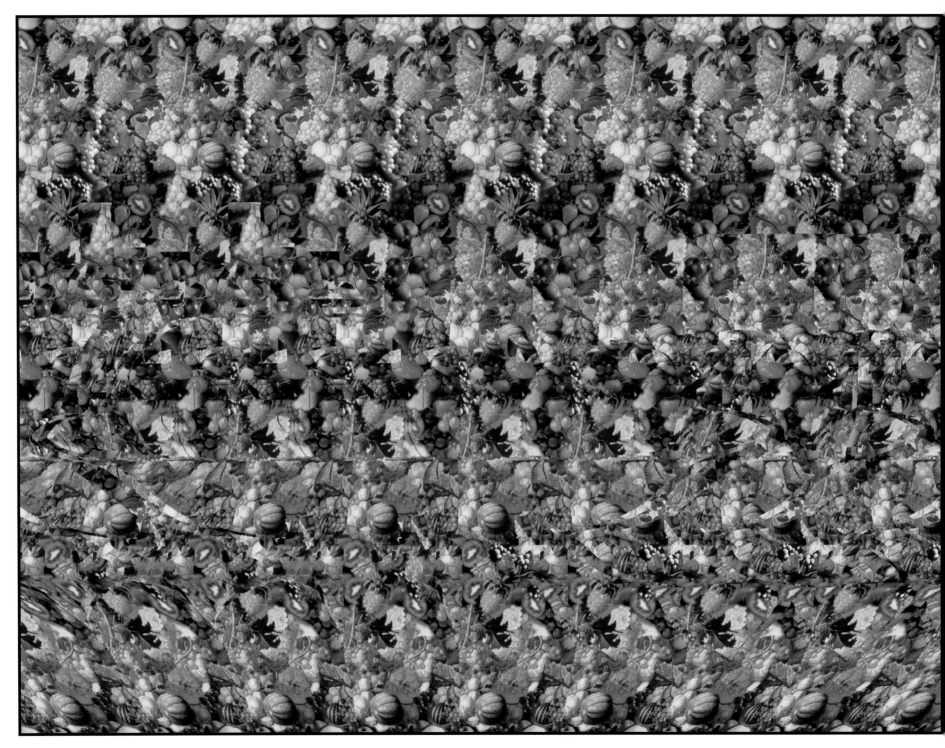

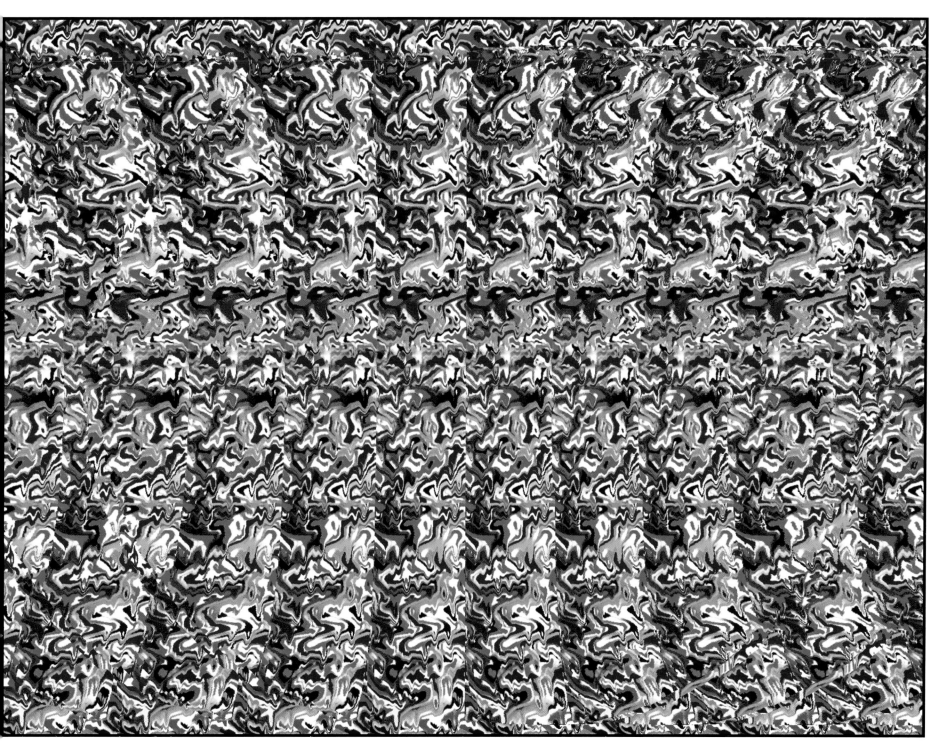

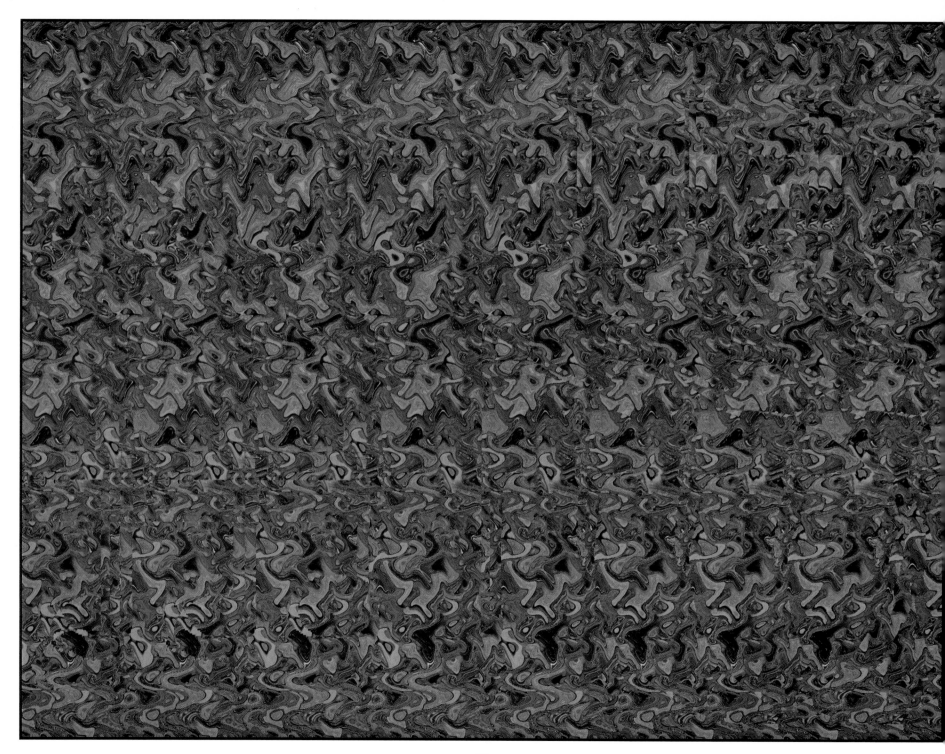

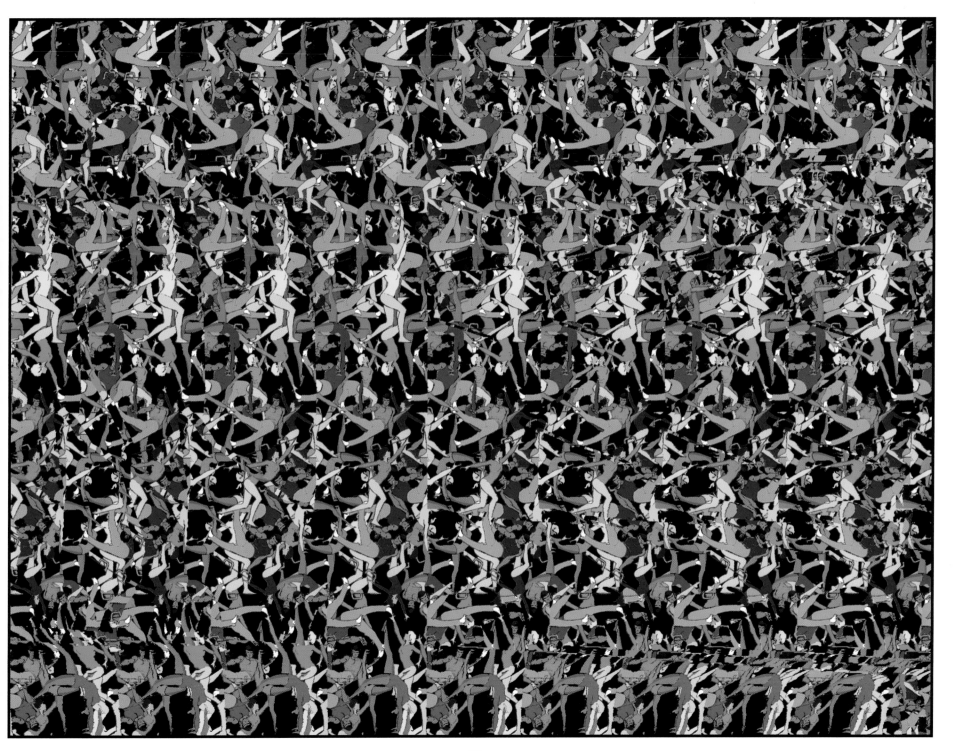

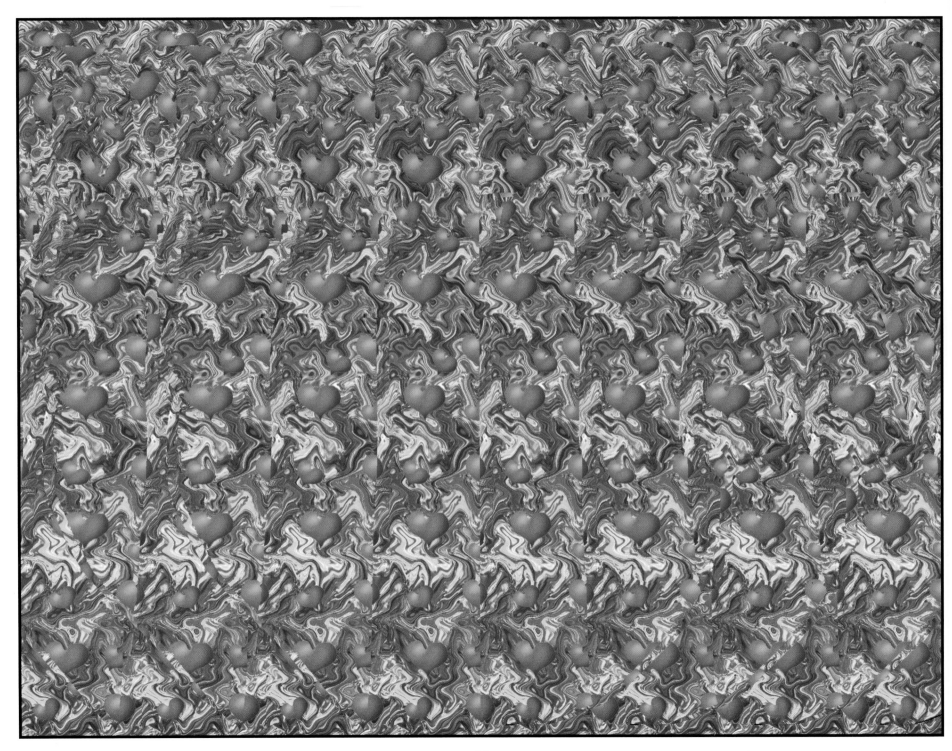

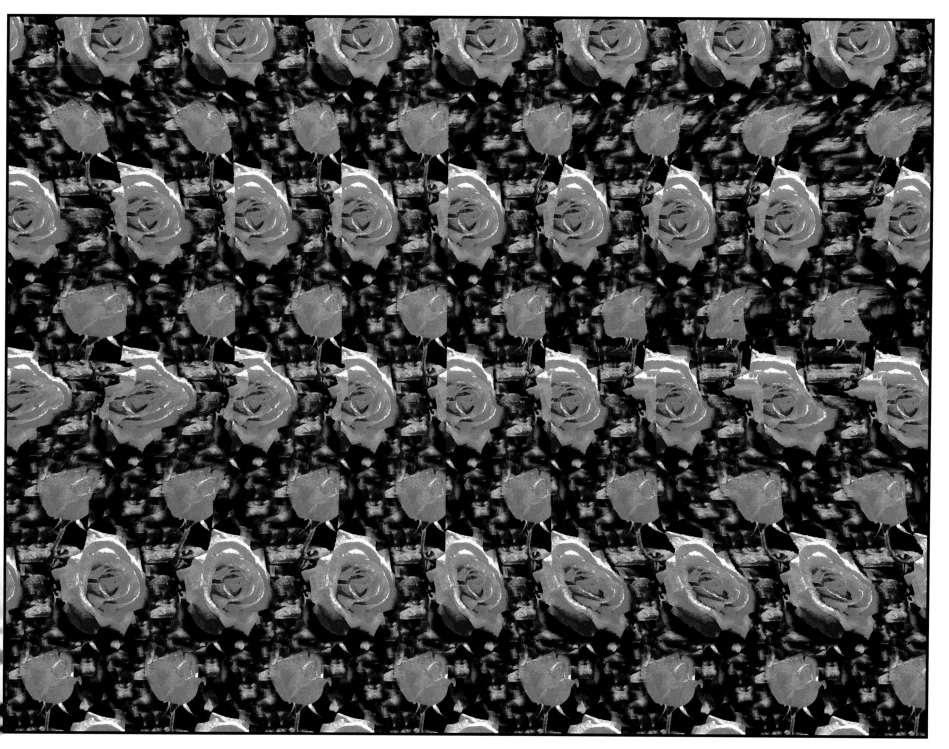

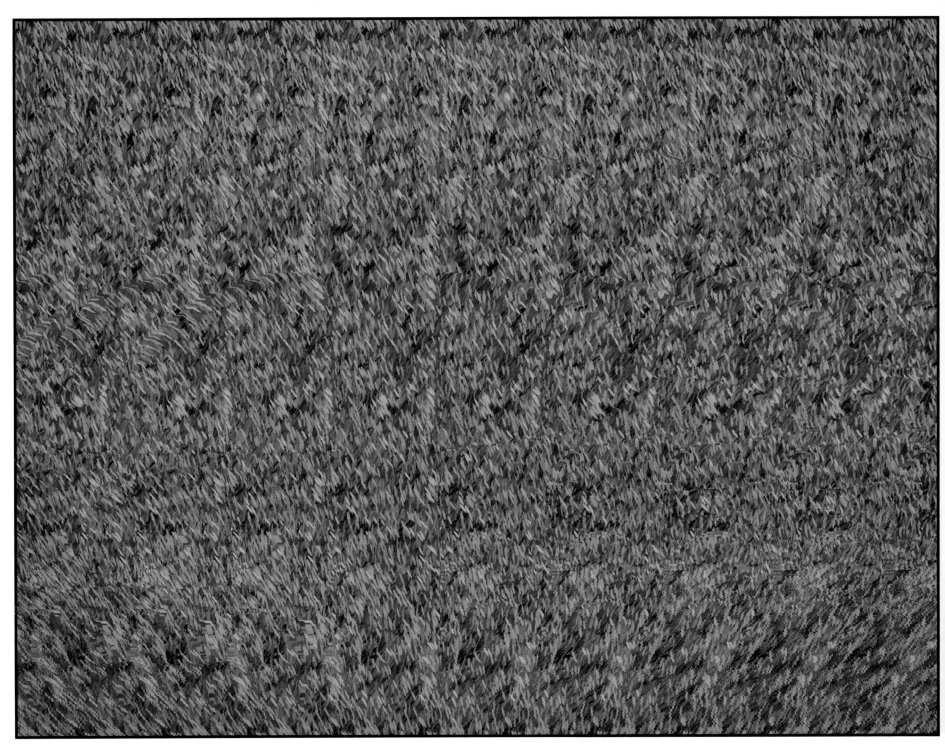

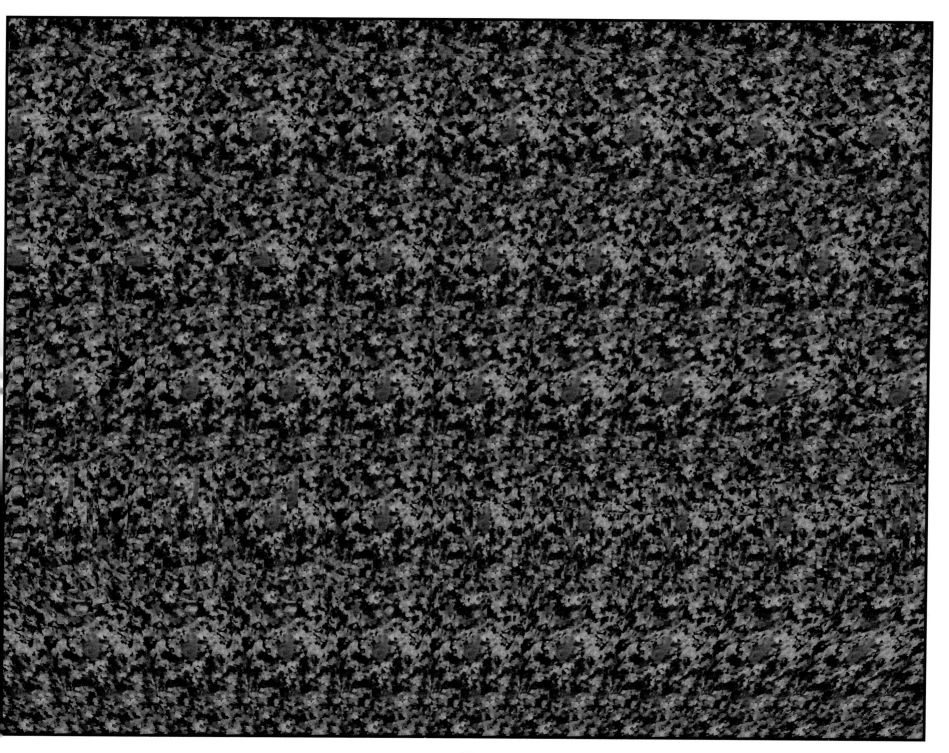

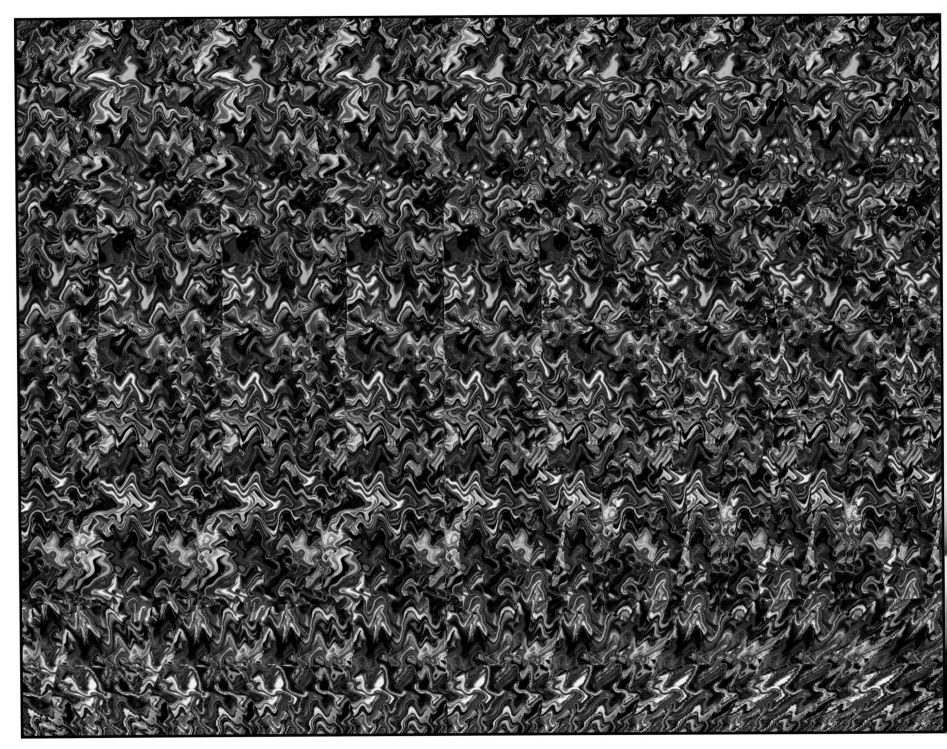

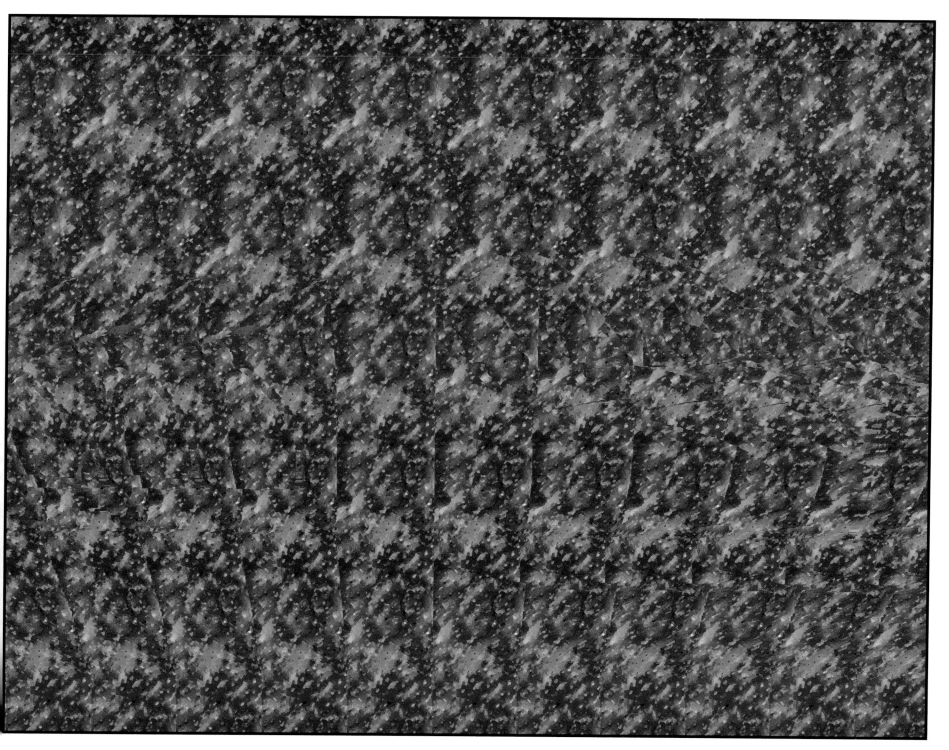

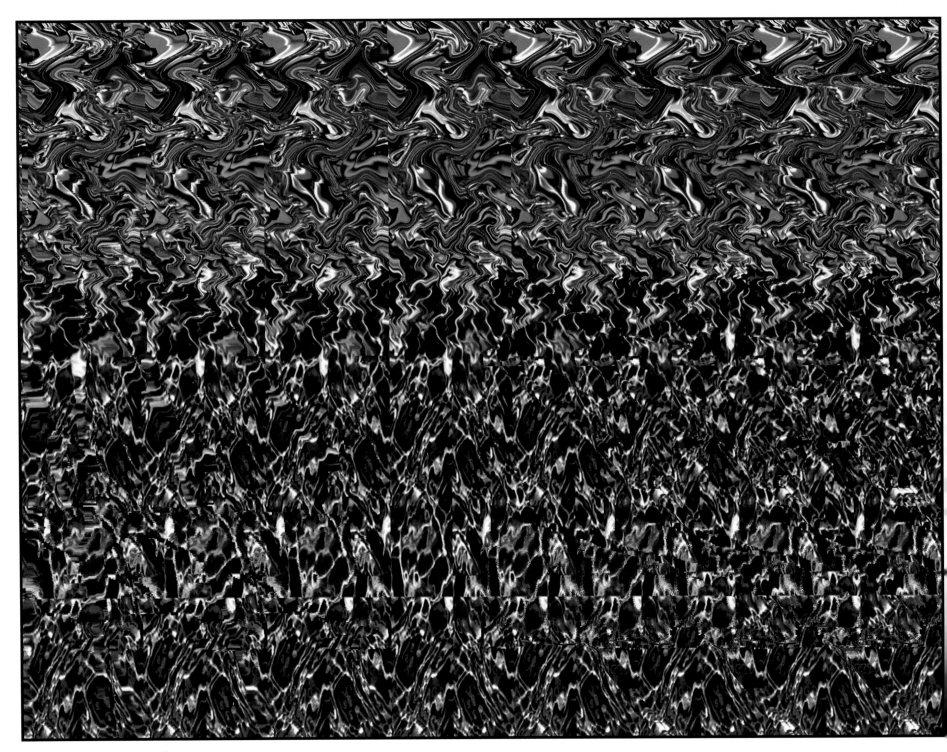

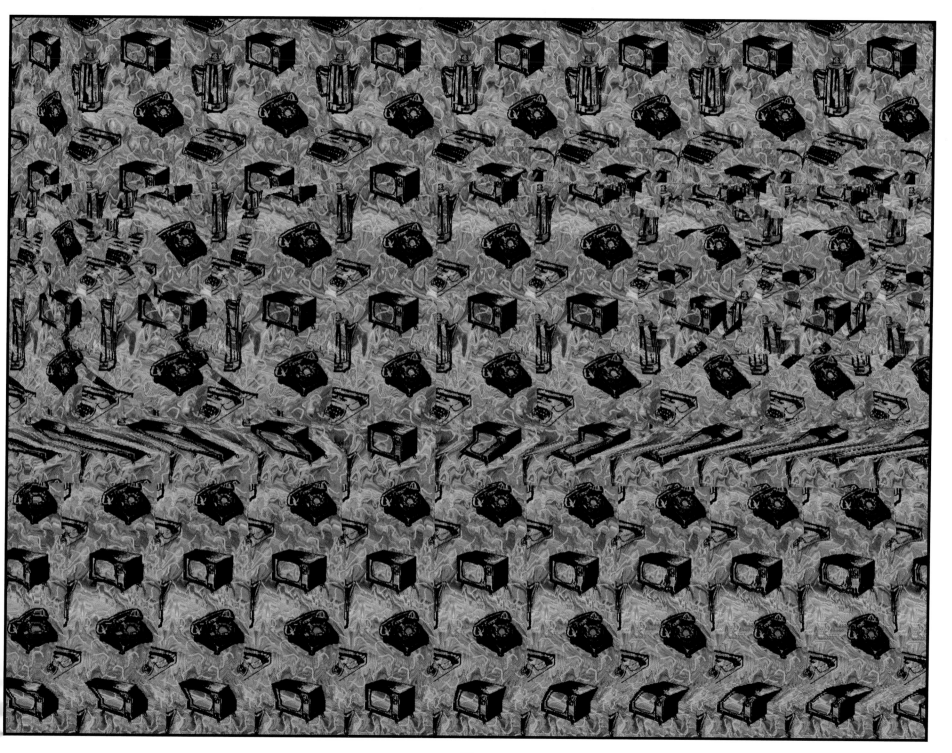

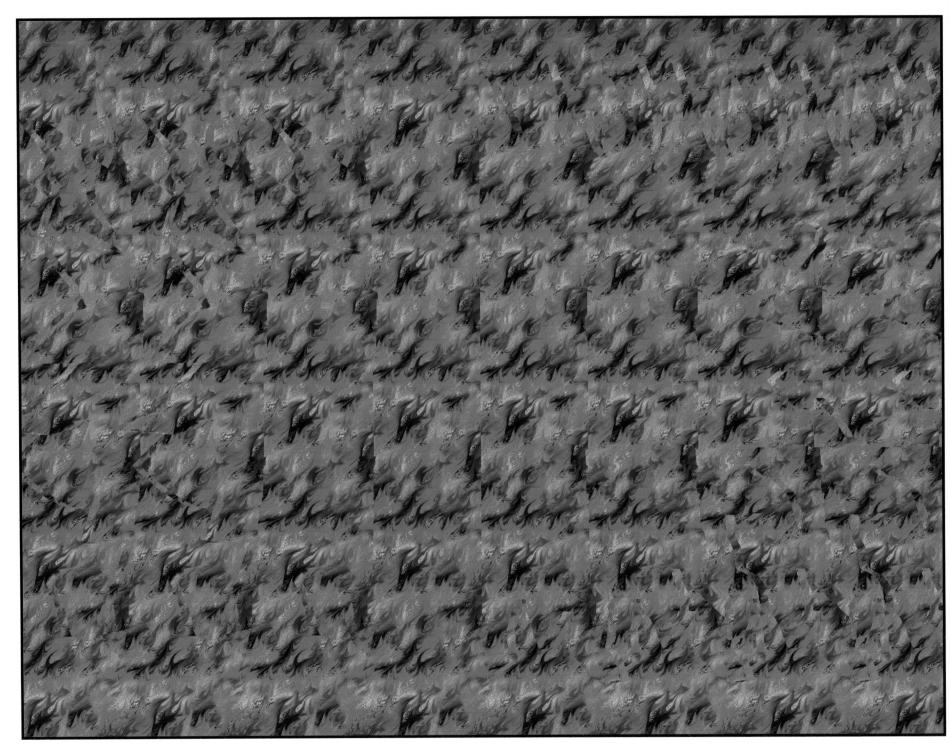

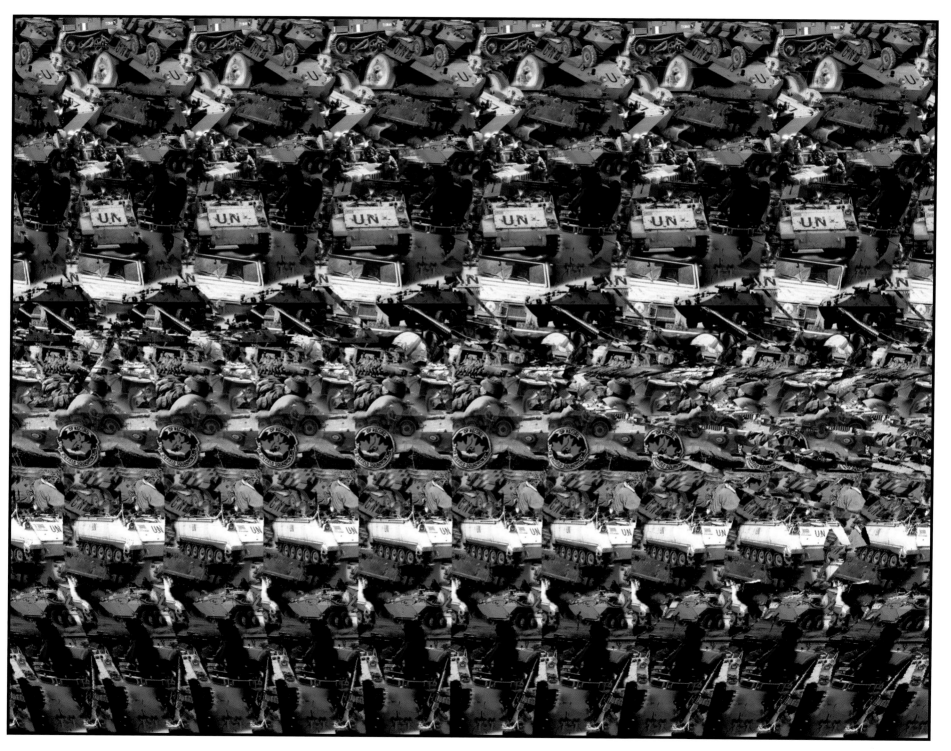

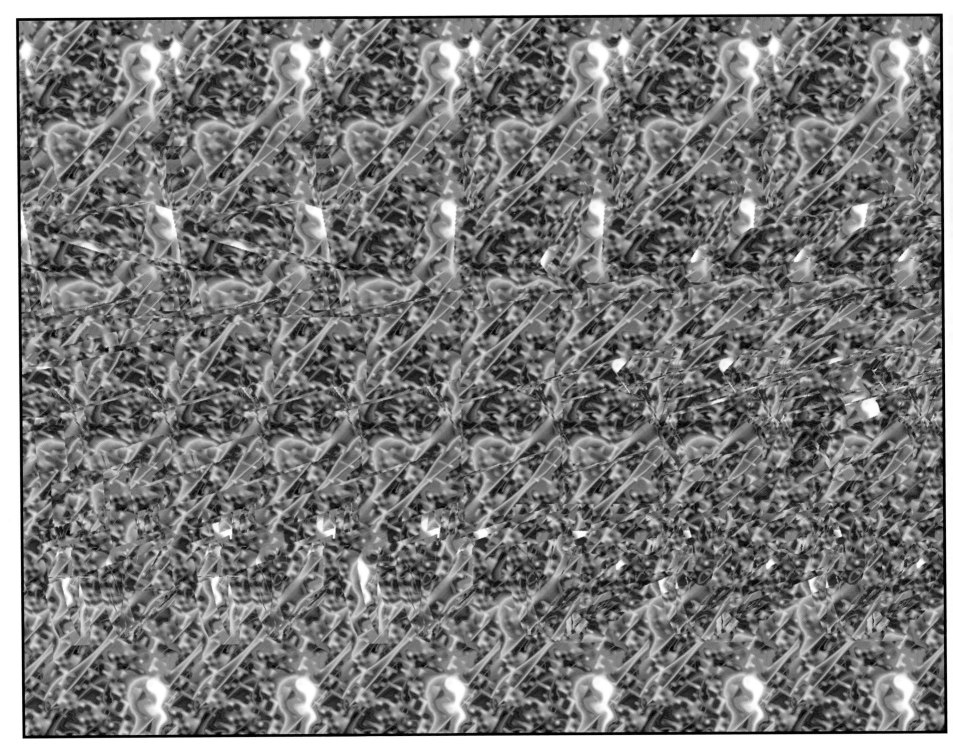

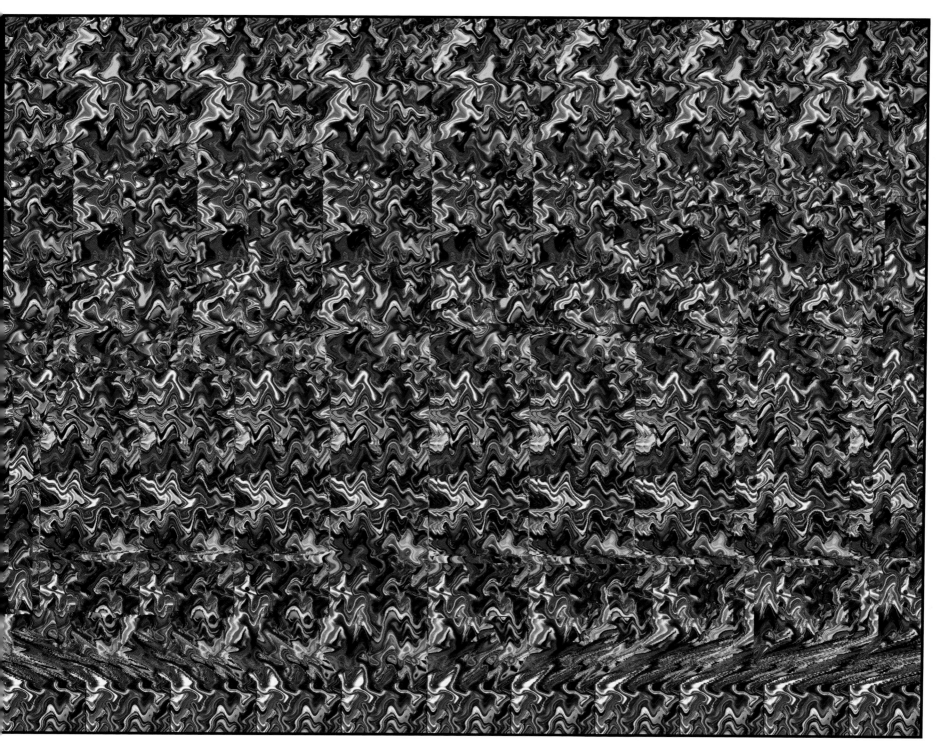

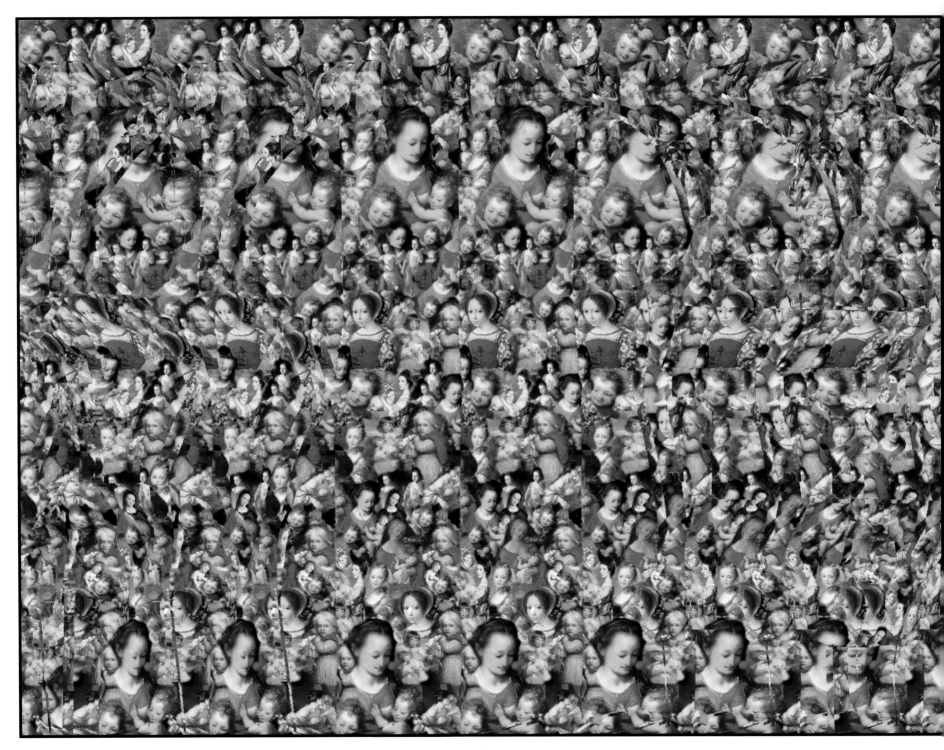

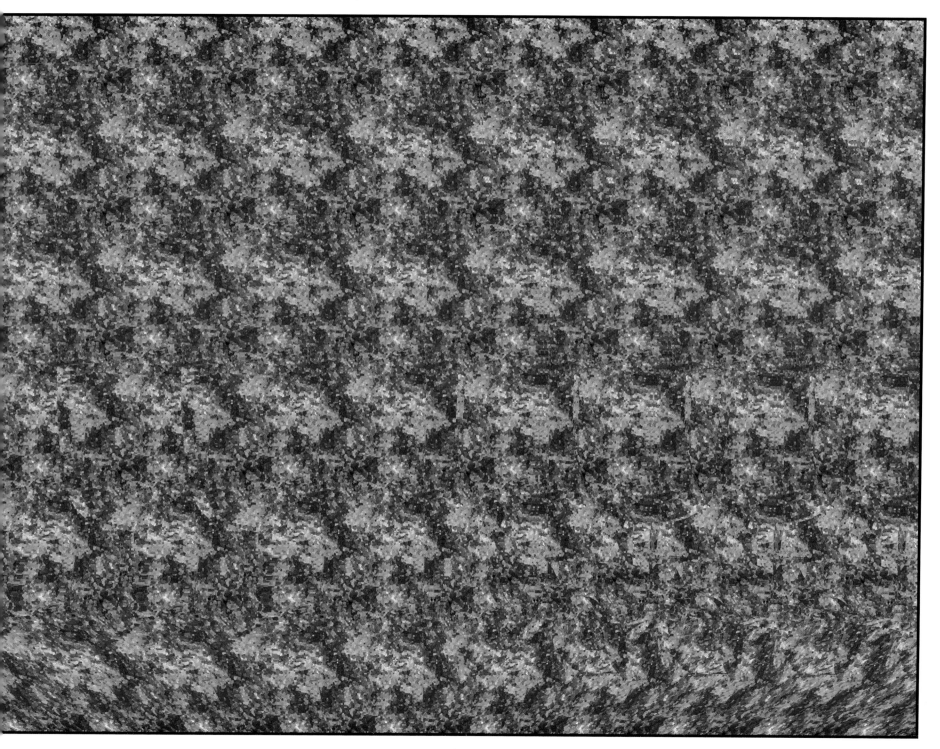

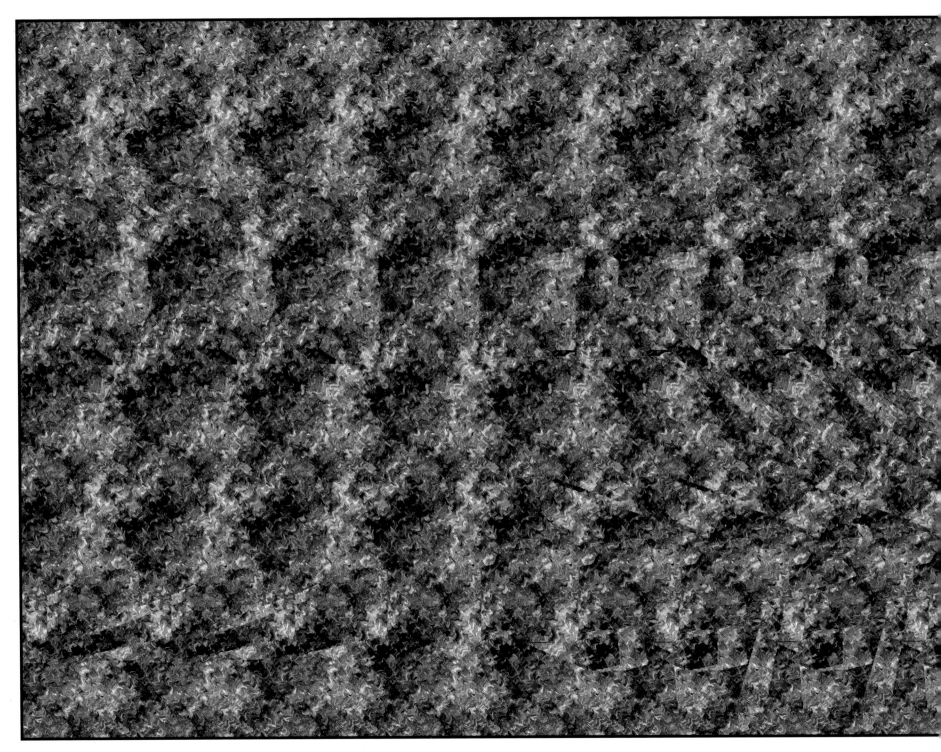

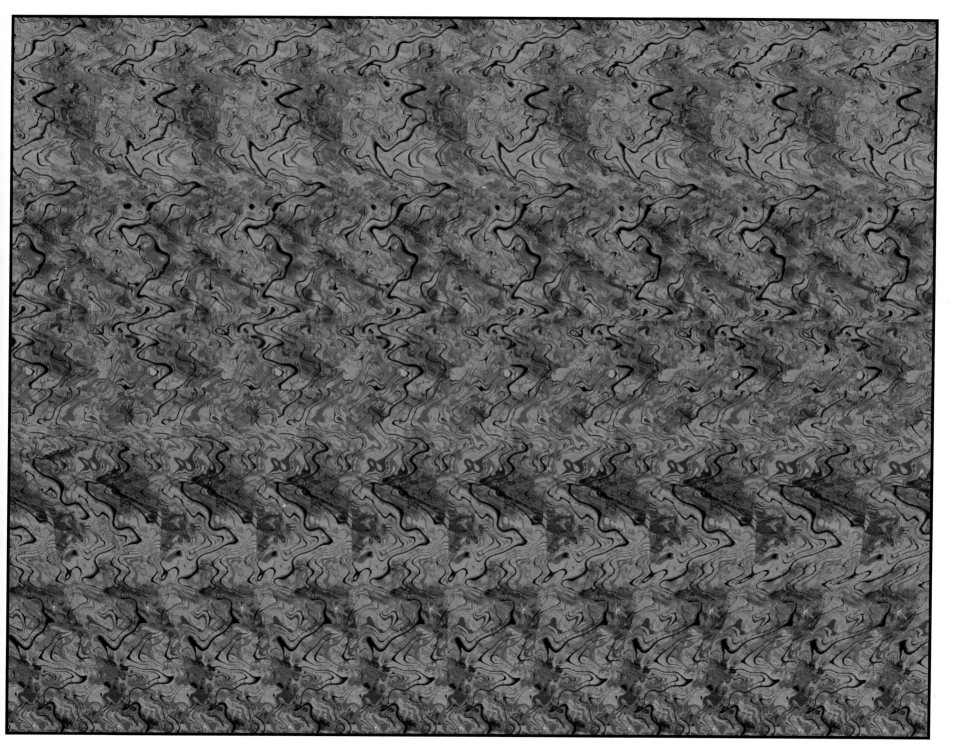

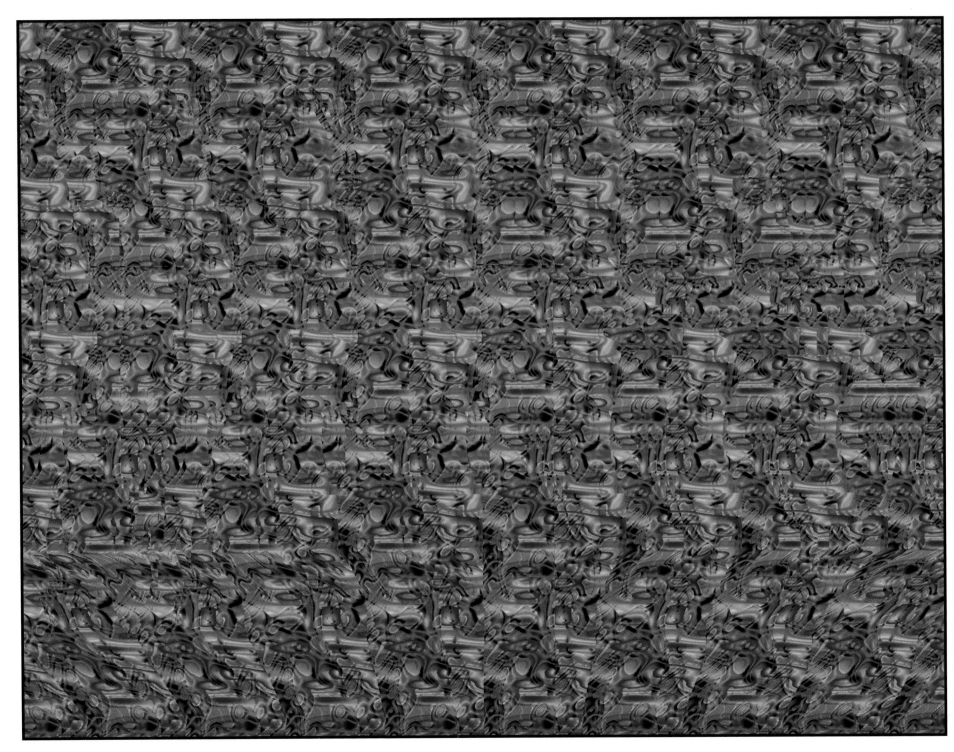

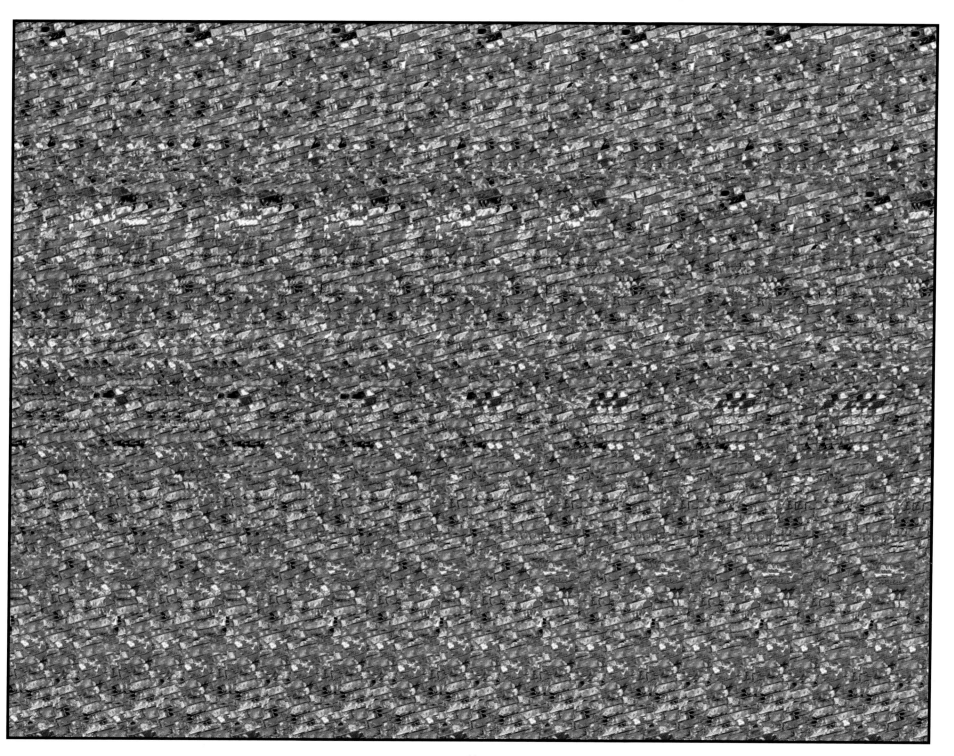

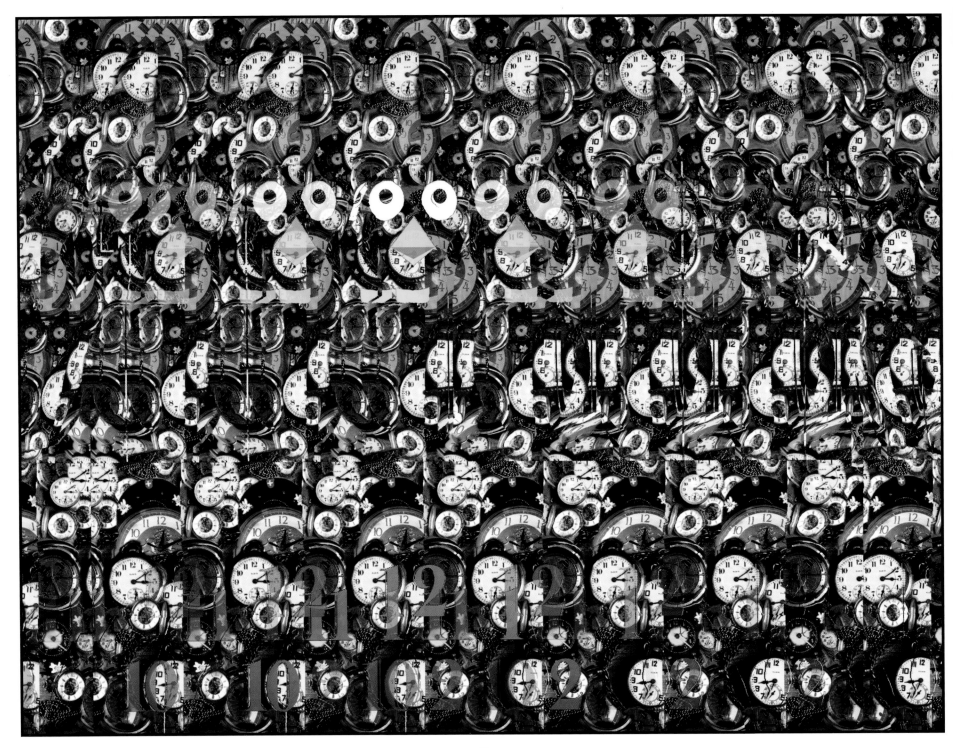

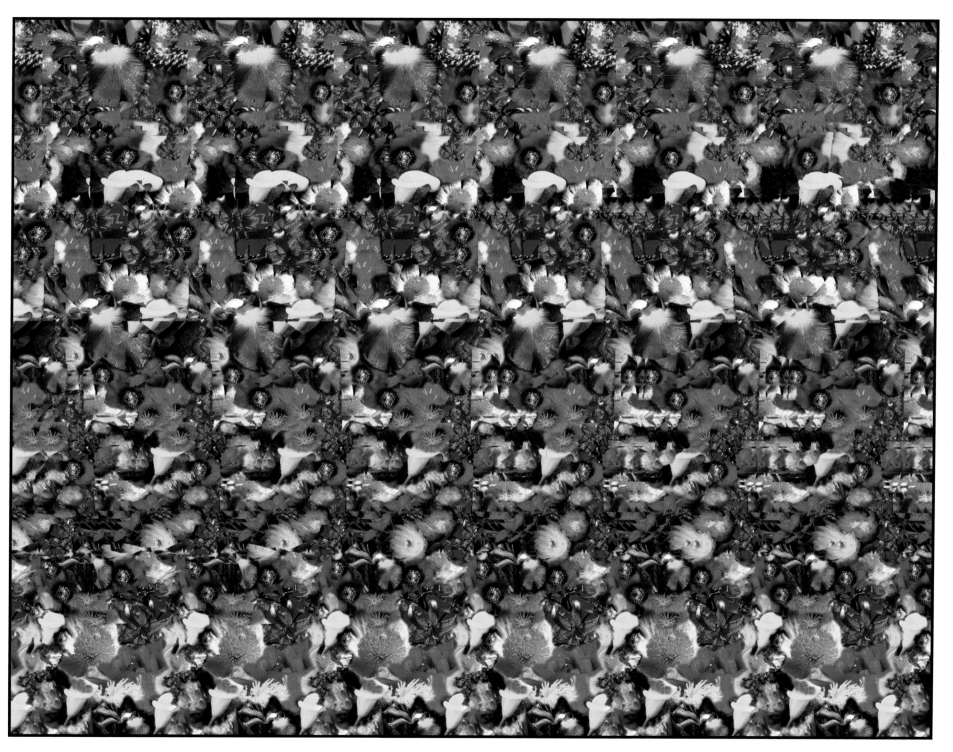

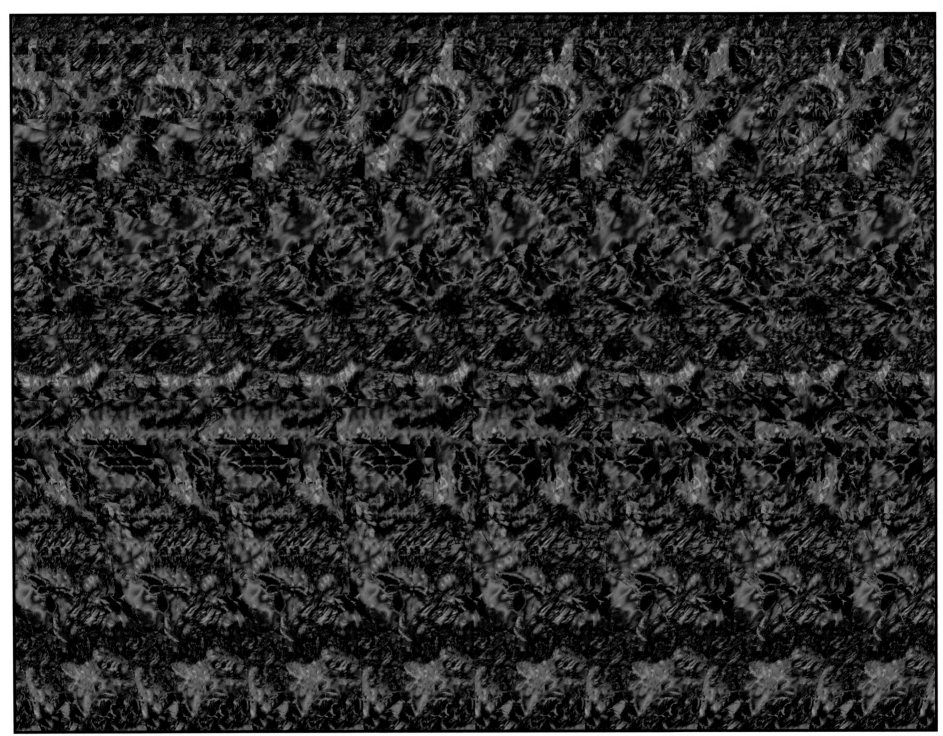

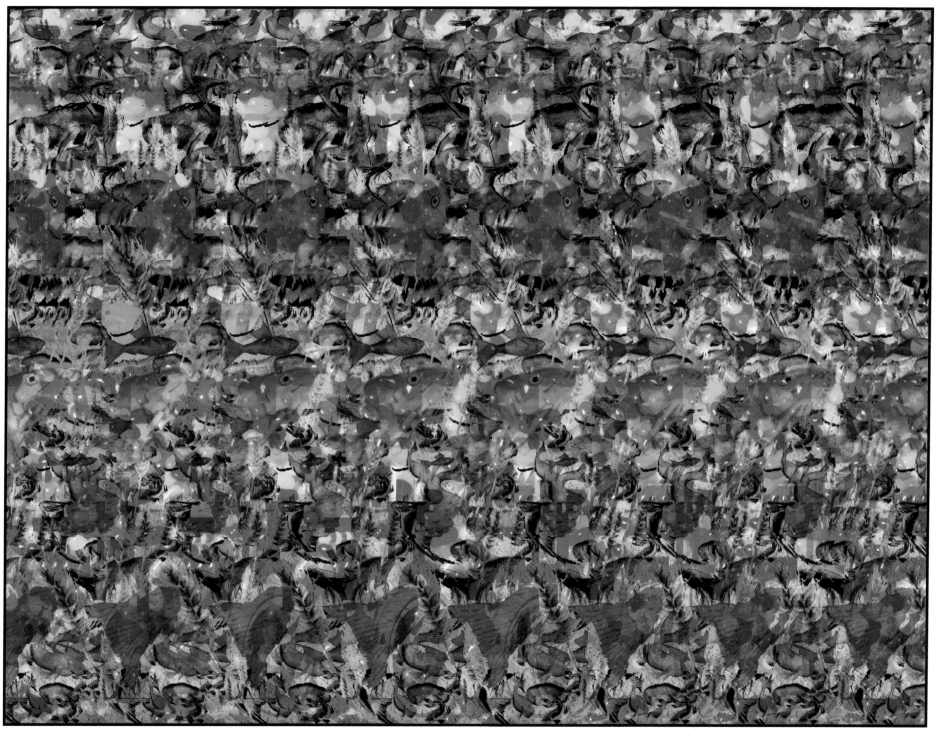

Appearing from the book <u>3D Bible Stories</u>, by *3D Revelations* — Otherworld Artyfax, Simi Valley, CA.

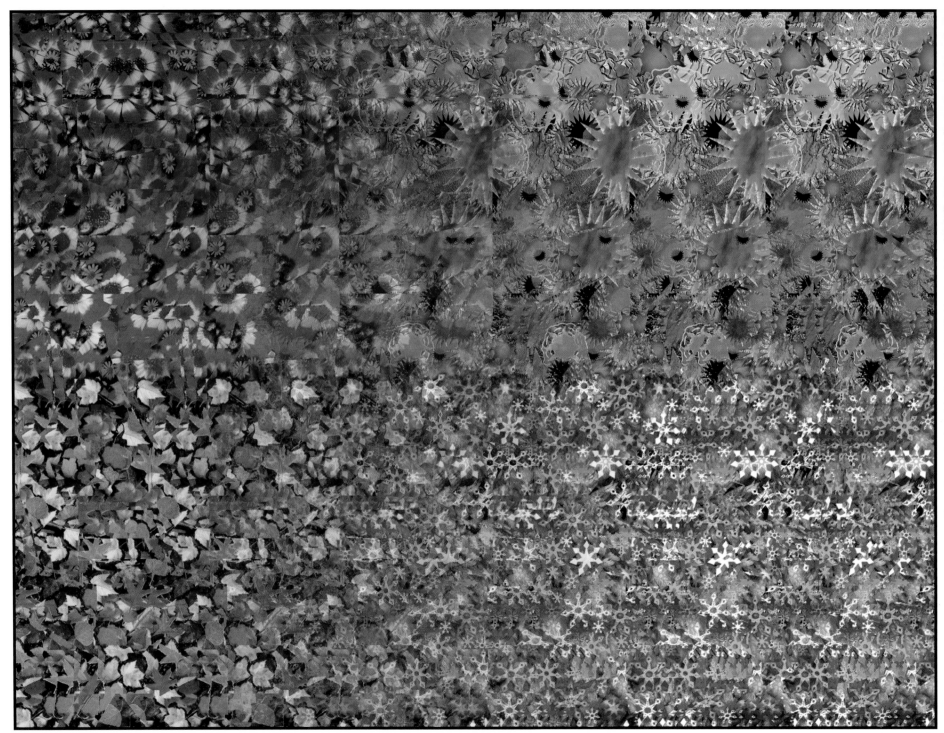

Appearing from the book <u>3D Bible Stories</u>, by *3D Revelations* — Otherworld Artyfax, Simi Valley, CA.

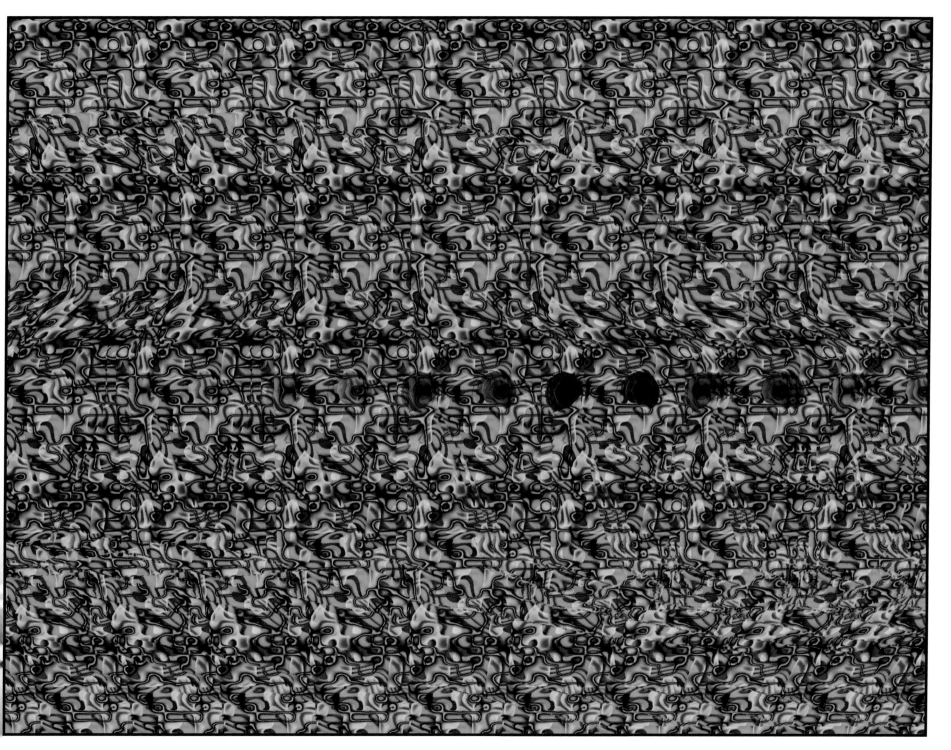

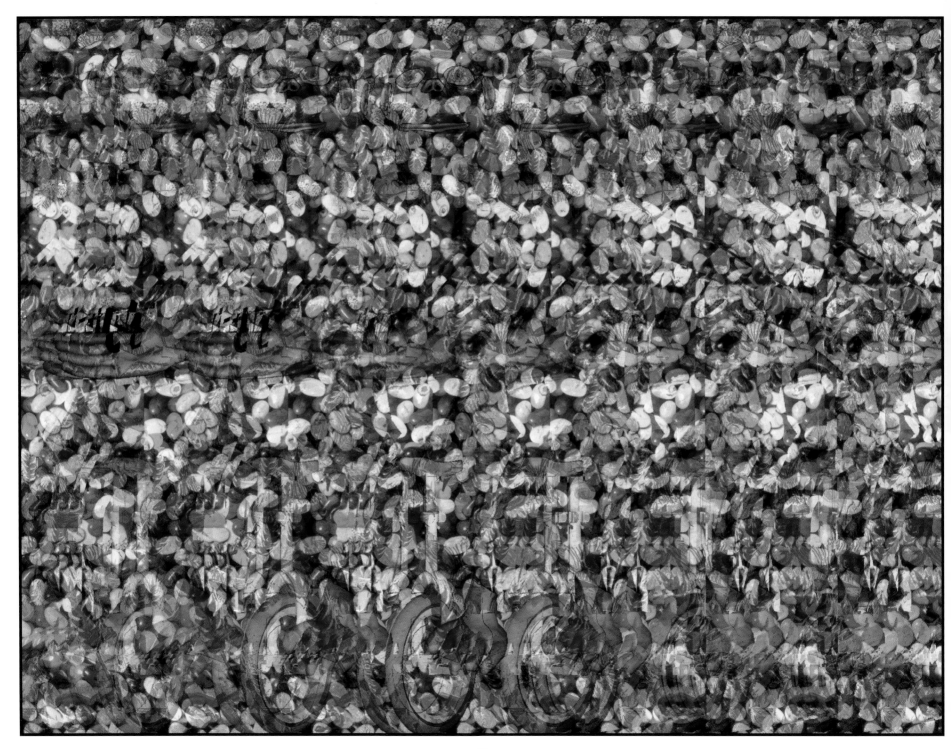

Page 7

Page 8

Page 9

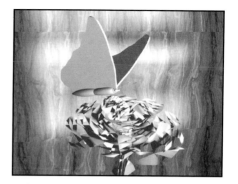

Page 10

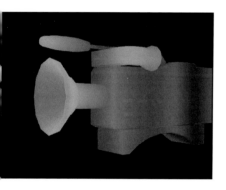

Page 11

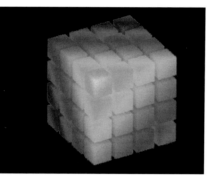

Page 12

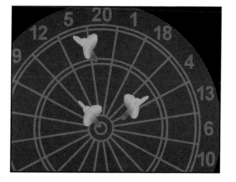

Page 13

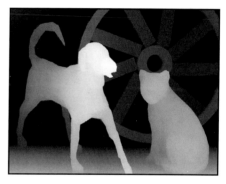

Page 14

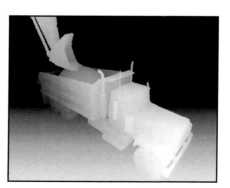

Page 15

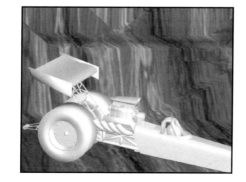

Page 16

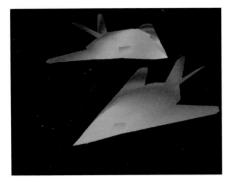

Page 17

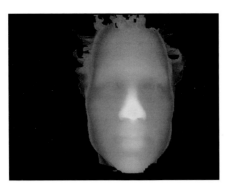

Page 18

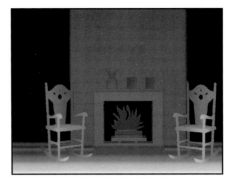

Page 19

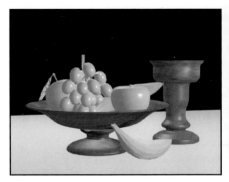

Page 20

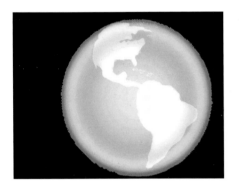

Page 21

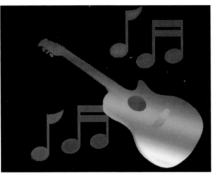

Page 22

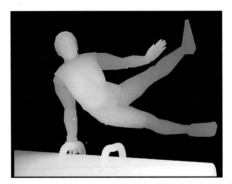

Page 23

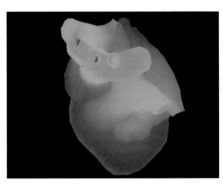

Page 24

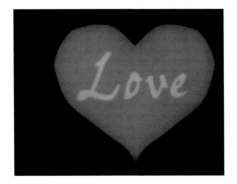

Page 25

Page 26

Page 27

Page 28

Page 29

Page 30

Page 31

Page 32

Page 33

Page 34

Page 35

Page 36

Page 37

Page 38

Page 39

Page 40

Page 41

Page 42

Page 43

Page 44

Page 45

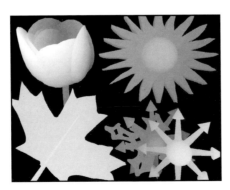

Page 46

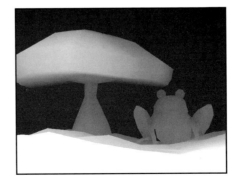

Page 47

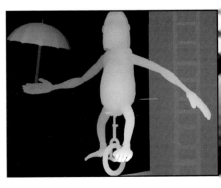

Page 48

This image (of stars) was created with the full-featured version of Stereolusions

(FOLD HERE)

NO POSTAGE
NECESSARY IF
MAILED IN THE
UNITED STATES

BUSINESS REPLY MAIL

FIRST CLASS MAIL PERMIT NO. 9189 RANCHO CUCAMONGA, CA

POSTAGE WILL BE PAID BY ADDRESSEE

I/O SOFTWARE, INC.
P. O. BOX 10
RANCHO CUCAMONGA, CA 91729-9913